FIGHTING HISTORY

FIGHTING
HISTORY

Edited by Greg Sullivan

With contributions by Dexter Dalwood

and Mark Salber Phillips

Tate Publishing

250 YEARS OF BRITISH HISTORY PAINTING

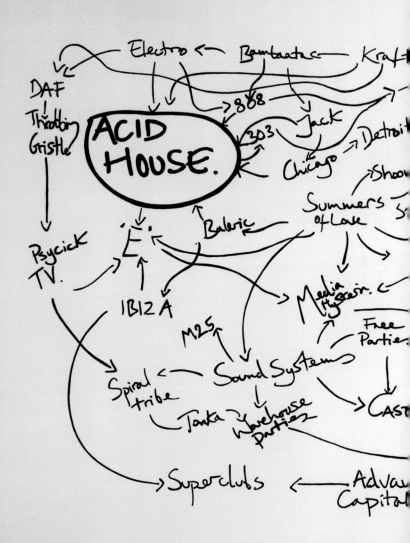

JEREMY DELLER
The History of the World 1997–2004

Hardcore → Break- Drum N'
beat Bass

808 ⇄ Has
State

AVE

The North

LF

Gerald

Melancholy

Clapham
Common

Parks

Civic
Pride → PFI

BRASS
BANDS.

Orgreave

Return
to Work

Pit Bands

Bandstands

The
Miner's
Strike

Deindustrialization.

Festivals ← Open Air.

Privatisation

First published 2015 by order of the Tate Trustees
by Tate Publishing, a division of Tate Enterprises Ltd,
Millbank, London SW1P 4RG
www.tate.org.uk/publishing

on the occasion of the exhibition *Fighting History*
Tate Britain, 9 June – 13 September 2015

A catalogue record for this book is available from the British Library
ISBN 978 1 84976 358 5

Designed by The Studio of Williamson Curran
Colour reproduction by DL Imaging Ltd, London
Printed and bound in the Czech Republic by PB Print

Front cover: John Singleton Copley, *The Death of Major Peirson, 6 January 1781* 1783

Measurements of artworks are given in centimetres, height before width

THE STORY OF BRITISH HISTORY PAINTING

Greg Sullivan

WHAT IS THE HISTORY IN HISTORY PAINTING?

Mark Salber Phillips

CONTEMPORARY HISTORY PAINTING

Dexter Dalwood interviewed by Greg Sullivan

THE STORY OF BRITISH HISTORY PAINTING

Greg Sullivan

But for a painter we never had, as yet, any of note that was an Englishman that pretended to history painting. I cannot attribute this to anything but the little encouragement it meets with in this nation.

William Aglionby, *Painting Illustrated in Three Dialogues* (London 1684)

It was a familiar refrain of critics of British art from the seventeenth to the nineteenth centuries that history painting, considered the highest genre of art, was a noble aspiration for painters, but an unattainable one in the British context. The elevated depiction of scenes from history, mythology, scripture or poetry could not succeed here due to a lack of support, a lack of skill, a British disdain for overblown drama, and a host of other reasons. Indeed, twentieth-century scholarship has taken a similar line – history painting was a much-vaunted ambition, but was notable by its absence.

It is a familiar story, but a very partial one. For a genre that is often said to have failed, there has been a surprisingly large body of ambitious history painting produced here in the last 250 years. Even in the twentieth and twenty-first centuries, when it might reasonably be assumed that the onslaught of French modernism and the postmodern resistance to grand narrative must spell its death, there are nevertheless artists addressing themes and forms explicitly drawn from the history painting tradition.

So what might a history of British history painting look like, if not a tale of martyred (and occasionally pompous) outsider artists, or of the eclipse of academic painting by late nineteenth-century modernism? And given the widespread interest today in a revival of history painting (broadly conceived) in contemporary art, what is it about this genre that draws artists to its ethos, subjects and forms?

One story of British history painting might begin with Robert Edge Pine (1730–88), the inaugural winner of the first prize for

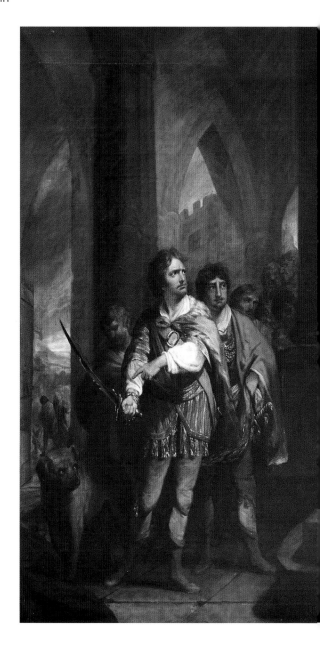

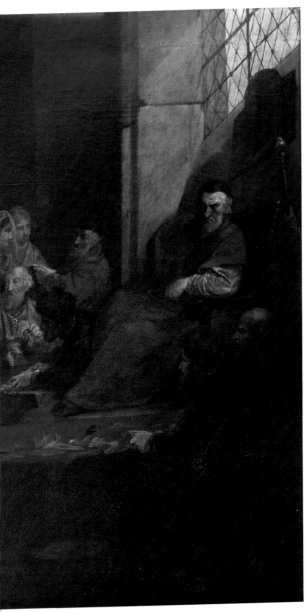

1. ROBERT EDGE PINE
John De Warenne, 6th Earl of Surrey, Giving his Answer to the
King's Justices on the Enforcement of the Statute of Quo Warranto 1278 1771

history painting in Britain. Offered in 1760 by the London Society for the Encouragement of Arts, Manufactures and Commerce, who as often offered prizes for machines to cut vegetables as for fine art, the prize was won by Pine for a scene of the *Surrender of Calais to Edward III*. He went on to win another prize with his *Canute Reproving his Courtiers* in 1763. These works are meditations on the proper limits of monarchical power, at a time when the issue was debated in history books, and in contemporary politics.

Both works have since perished but one painting survives from Pine's history painting pomp – *John De Warrene, 6th Earl of Surrey, Giving his Answer to the King's Justices on the Enforcement of the Statute of Quo Warranto 1278* (FIG.1). It depicts the scene when Earl Warren, the figure to the left, refused to comply with a parliamentary edict requiring him to deliver proof of his entitlement to his lands. The statute was being used by King Edward I to levy fines on nobles whom he knew had no documentary proof of their entitlement, even though their claims were long established. Earl Warren is purported to have drawn a rusty sword from his scabbard and said to the bailiffs 'this is the instrument by which my ancestors gained their estate, and by this I will keep it as long as I live' (Paul Rapin-Thoyras, *History of England*, 1725–31, vol.3, p.11).

It is, perhaps, not what we expect of a history painting, usually thought to be a reactionary form, or at its worst a vehicle for state propaganda. Yet there are, in truth, few examples of official history painting in the British context (the fresco cycles at the Houses of Parliament in the second half of the nineteenth-century being a notable exception), whilst it is not hard to find a tradition of independent history painting that stretches from Pine (a radical in politics as well as art) through the following centuries. The constant possibility of insurrection against the unjust use of state power can be seen as a motif all the way to Dexter Dalwood's *Poll Tax Riots* of 2005 (FIG.18).

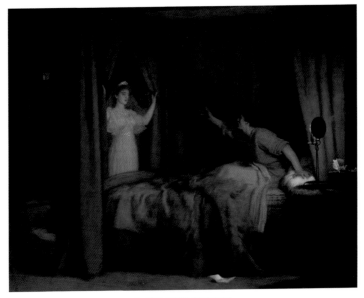

2. JOHN EVERETT MILLAIS
Speak! Speak! 1895

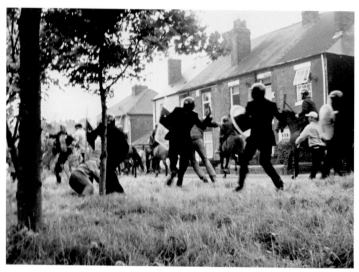

3. JEREMY DELLER
The Battle of Orgreave Archive (An Injury to One is an Injury to All) 2001

WHAT IS A HISTORY PAINTING?

If not necessarily elitist, academic, or politically regressive, what then is a British history painting? It is a debate to which artists, critics and academics have frequently returned. In Britain there are dissenters from almost every definition of what constitutes a history painting. It must be a subject from history, scripture or mythology, yet invented subjects such as *Speak! Speak!* by John Everett Millais (FIG.2) are commonplace in the eighteenth and nineteenth centuries; it must be based on the human figure in action, usually with multiple characters, but Henry Wallis's *The Room in which Shakespeare was Born* (FIG.24) contains no figures at all; it must be on a grand scale, although the most popular early history paintings were cabinet-sized for domestic purchasers; and so on. The necessity of history painting was agreed, but with widespread disagreement over its necessary constituent parts. Recently Mark Salber Phillips has compared the British history painting to the mythological ship the *Argo*, which was constantly under repair but always sailing heroically on.

The history paintings we are exploring here, however – those that can be seen to find echoes in contemporary practice – tend to depict a telling moment or narrative that prompts us to consider our place in history, as an individual or as a society. The question of where we fit in history is one that eighteenth- and nineteenth-century Britons were more accustomed to asking of themselves than we are today (when Tony Blair claimed to feel 'the hand of history' before the signing of the Good Friday agreement in April 1998 there was widespread lampooning). To judge from the number of new artworks engaging with the question of where we fit in history (and who the 'we' is that is fitting into history, and what the 'history' is that we are fitting into), it seems we are engaging with the issues anew.

The ability of an artwork to engage our emotions and prompt us to think about our place in history is a difficult achievement, and little wonder so many paintings fail. Those who achieve it, however, perhaps deserve their place at the peak of the hierarchy of genres. Emotional engagement is the hardest task.

Sometimes the work explicitly refers us to subjects that are still alive in the emotions of viewers, as in Richard Hamilton's response to the troubles in Northern Ireland (FIG.17), or Jeremy Deller's recreation of the *Battle of Orgreave* (FIG.3). Conversely, artists may chose long-past themes that nevertheless provoke meditation on still-pertinent, even timeless, questions. Agrippina's stoicism before the crowd, despite being racked with grief at the death of her husband, might be distant historically but the scene touches on emotions that are universal (FIG.28). For all its elevation the question posed by a history painting is often a very simple one – what would *you* do in an extreme situation like this?

The history painter often looks to the extremities. Major Peirson's death in a skirmish with the French (an encounter he pursued in contravention of army orders) being avenged by his black servant; Amy Robsart's death as she falls – or is pushed – down a flight of stairs (her husband Lord Robert Dudley, favourite of Elizabeth I, was suspected of orchestrating her demise); the Earl of Chatham's collapse in the House of Lords as he delivers his final speech on American independence (FIG.6). The history painting often catches our attention to provoke us to think about the nature of heroism, the value of death to the defence of the nation, or even the actual end of most of the human race in a deluge brought about by Nature or by God (FIGS.31, 33, 34).

But the seen effects do not always need to be extreme. Our relationship to history can be suggested as much by an empty room, if that room is a reconstruction of the place in which Shakespeare was born. Henry Wallis's scene takes a nineteenth-century historicist interest in the minutiae of history to give a sense of how an unremarkable room can be the origins of a remarkable man. Similarly Millais's *The Boyhood of Raleigh* takes the simple gesture of a sailor pointing out to sea as he engrosses the young Walter and his brother with his tales of life aboard ship to suggest that the pivotal historical moment can be rooted in the everyday and the apparently unremarkable (FIG.9).

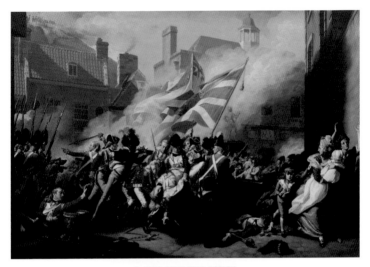

4. JOHN SINGLETON COPLEY
The Death of Major Peirson, 6 January 1781 1783

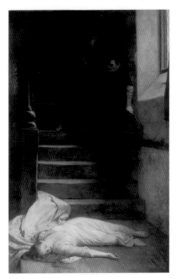

5. WILLIAM FREDERICK YEAMES
Amy Robsart exh.1877

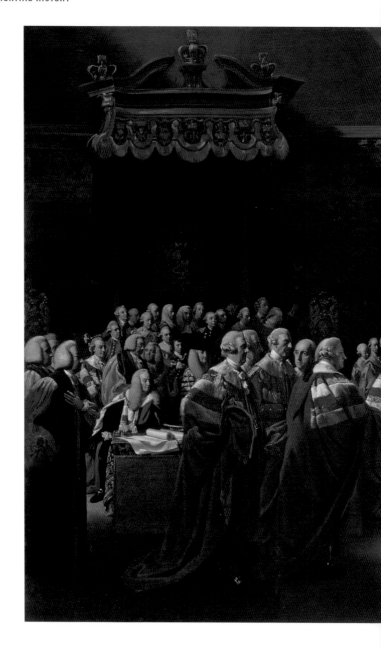

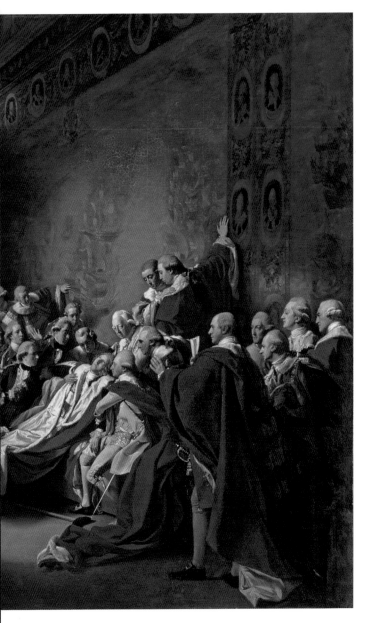

6. JOHN SINGLETON COPLEY
The Collapse of the Earl of Chatham in the House of Lords, 7 April
1778 1779–80

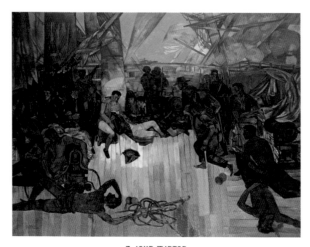

7. JOHN MINTON
The Death of Nelson 1952

8. CHARLES HOLROYD
Death of Torrigiano exh.1886

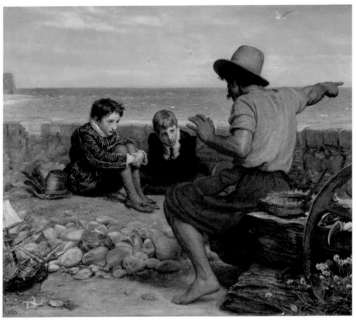

9. JOHN EVERETT MILLAIS
The Boyhood of Raleigh 1870

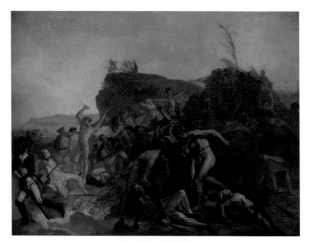

10. JOHAN ZOFFANY
The Death of Captain James Cook, 14 February 1779 c.1795

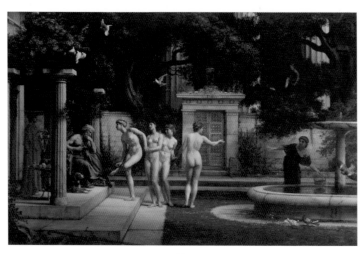

11. EDWARD POYNTER
A Visit to Aesculapius 1880

ARTISTS AND HISTORY

Another of the recurring aims of the history painter is to make visual allusions to the history of art itself. The history painting usually refers back to earlier art, painted or sculpted. The poses of two of Captain Cook's men recall the classical statues of the *Dying Gaul* and the *Discobolus* (FIG.10), whilst Copley's *Chatham* echoes the posture in *Christ's Deposition from the Cross*. With a connoisseur's intellectual twist, in *A Visit to Aesculapius* (FIG.11) Edward Poynter depicts Venus displaying her injured foot to the Greek god of healing and medicine, contorted in a similar way to the boy removing a thorn in the Greco-Roman statue known as *Spinario*. The eighteenth- and nineteenth-century history painter was expected to have imbibed the history of art, and to have the skill to intimate it to a knowing audience. The appropriation of the historical canon of art signals to the audience the ambitions of the work to be a part of that history, or to be a challenge to it.

This reflexivity about how to indicate history, whilst drawing attention to the art of the history painter, is perhaps most evident in twentieth-century painting. Allen Jones's *The Battle of Hastings* (FIG.13) is an abstract design based on diagrams that the artist produced of the movements of the opposing armies at the famous battle in 1066. It renders the shapes as a colourful explosion, reminiscent of those we see throughout the battle paintings of the earlier centuries, from Copley to De Loutherbourg (FIG.14). Jones also includes a union flag, and references to contemporary paintings by Morris Louis and Sidney Nolan. Drawing attention to the process of representing history via abstract diagrams and motifs problematises our relationship to events, and to history itself.

Elsewhere the effects are not quite so distancing. Richard Hamilton's *The citizen* draws on a well-established form of history portrait, in which a figure is seen against a background, or a set of props, that indicate for us the reasons why this person is taking a place in history (FIG.17). Joshua Reynolds's *Colonel Tarleton*, a veteran of the US War of Independence, stands beside a cloud of cannon smoke (FIG.16). *The citizen* shows

12. RICHARD EURICH
The Landing at Dieppe, 19th August 1942 1942–3

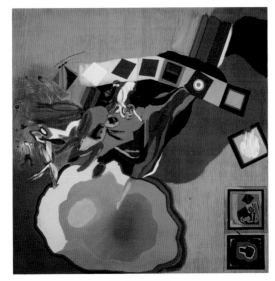

13. ALLEN JONES
The Battle of Hastings 1961–2

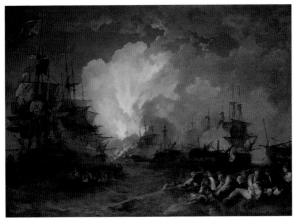

14. PHILIP JAMES DE LOUTHERBOURG
The Battle of the Nile 1800

15. MICHAEL FULLERTON
Loyalist Female (Katie Black) Glasgow, 3rd July 2010 2010

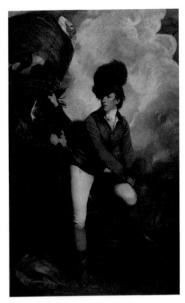

16. JOSHUA REYNOLDS
Colonel Tarleton 1782

17. RICHARD HAMILTON
The citizen 1981–3

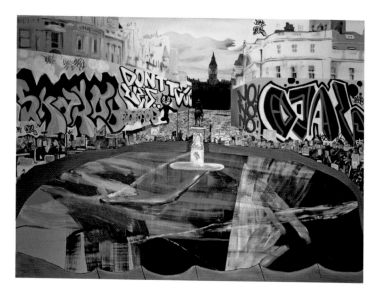

18. DEXTER DALWOOD
The Poll Tax Riots 2005

an Irish republican prisoner stood against the swirls of excrement that he has smeared on the walls of his cell in a 'dirty protest' against his political incarceration. Of the many protesters that Hamilton saw on television news footage, he selected Hugh Rooney for his Christ-like appearance, with long hair, beard and blanket. The result is one of the most powerful of modern history paintings.

Dexter Dalwood's *Poll Tax Riots* depicts a real event, in a semi-imaginary setting (FIG.18). The painting shows Trafalgar Square, central London, where demonstrators against the 'poll tax' were charged by mounted riot police on 31 March 1990. The placards of the protestors, the statue of the mounted figure of *Charles I* by Hubert Le Sueur, and the view down Whitehall towards the Houses of Parliament are visible. Yet the centre of the Square now has the surface of a painting of a *Dutch Sea Battle* by Gerhard Richter (b.1932), the sky draws upon a painting by Henri Rousseau (1844–1910), and the London square is hemmed in by sections of the Berlin Wall. Dalwood's work is no reconstruction, but is a twenty-first century history painting, indicating the event and our relationship to the event, the relationship of the event to history, and the relationship of the painting to art history.

History painting explicitly confronts us with the highest aims of art. It never offers us an easy ride. It is a provoking and insistent art form. Its function is to make us reflect on history and the place of our times in the histories of the future. It also asks us to think art-historically about the object that we are looking at as an integral part of its affect, not just as an optional piece of research for the specialist. It is perhaps unsurprising that its high aims are not always achieved, or that the demands it makes on its viewer are not always appreciated.

Nevertheless, the signs are that we may be entering an age which has a renewed appetite for asking the big questions about history and art history, and that history painting, newly repaired and orientated for modern times, might continue, like the *Argo*, to sail on, addressing some of the fundamental concerns of its audience.

WHAT IS THE HISTORY IN HISTORY PAINTING?

Mark Salber Phillips

It is hardly possible to do justice to the long history of history painting – a tradition that grew up with the baroque and flowered in the eighteenth and nineteenth centuries, only to lose its privileged status for much of the twentieth century, and now finding new relevance again. And what should we make of its hold on Britain, a Protestant and commercial nation that (as William Hogarth, himself a history painter, protested) would always be uncomfortable with an art form that smacked of Catholic ritual?

History painting was the name Europeans gave to the most elevated species of art. Combining formal complexity with dignity and intellectual ambition, *histories* (as artists called them) were regarded as the highest form painting could take. (For the sake of clarity, in this essay I shall use the italicised form *history/histories* to designate history painting and distinguish it from written history.) Florence and Rome had nurtured the genre's beginnings and Paris claimed it in turn, but even iconophobic Britain could not afford to ignore its prestige. For centuries Europeans took it for granted that history painting was an essential ornament to national greatness. As Benjamin West exhorted the Royal Academy in 1792, the artistic achievements of Greece and Rome had immortalised the ancients: without similar talents, Britain's achievements might be lost to time.

History painting's potent combination of longevity and authority lasted well into the second half of the nineteenth century, only to be dismissed by key modernist theorists as tired, academic, moralistic, and sentimental. Not that the great history painters of the past were simply forgotten, nor that artists ceased to make history paintings, but modernist hostility to didactic narratives made it difficult to recapture the extraordinary importance once vested in the art form itself – a loss which we are only beginning to repair today.

A sense of importance, in fact, seems the best place to begin, since elevation (understood as a privileged a form of distance) was key to the definition of history painting throughout its long career. Typically genres are classified by some combination of subject

matter (landscape, portrait, still life) and medium (photograph, wood engraving, performance, etc.). If, for example, a friend tells me that she has inherited a charming landscape from a favourite aunt, I don't have much sense of its size or style, but I can grasp the artistic family to which it belongs. History painting, however, worked by another logic where *height* or dignity was the critical issue, not the subject matter as such.

The hierarchies essential to history painting favoured certain classes of narratives – especially the religious and the heroic. Nonetheless, what Joshua Reynolds liked to call 'the great style' had only a partial resemblance to history as commonly written at the time. Even when we add in sacred history we do not encompass all its subjects, which included classical myth and history, the poetry of Tasso, Ariosto, or Shakespeare, as well as the life of Christ and the saints, or stories from the Hebrew Bible. What held this diverse assembly together was not so much a consistent subject matter as the long-held conviction that the arts formed a natural hierarchy with *histories* at the peak.

The dignity commanded by history painting sprang from its ancient association with matters both public and sacred. These were images intended for royal courts and cathedrals, not for domestic settings. Public ideals shaped *history's* work at every level: its formal structure as well as its affective tone, its moral or ideological summons, as well as the codes that gave it intelligibility. The interplay of these four forms of engagement – formal, affective, summoning, and intelligibility – mediated the representation of the past, endowing each period of history painting with its own characteristic distances (For an extended discussion of this point, see my *On Historical Distance*, 2013). Formally, the neoclassical narratives of the eighteenth century aimed for impressive scale and complex organisation, combined with a special focus on the human figure. Affectively too, human feelings and actions took centre stage, often in displays of masculine courage, set off against female fragility and sacrifice. (FIG.19). *Histories* were expected to represent the Ideal, summoning humanity to strive for the highest possibilities. Above all perhaps,

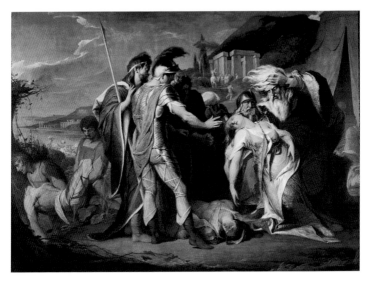

19. JAMES BARRY
King Lear Weeping over the Dead Body of Cordelia 1786–8

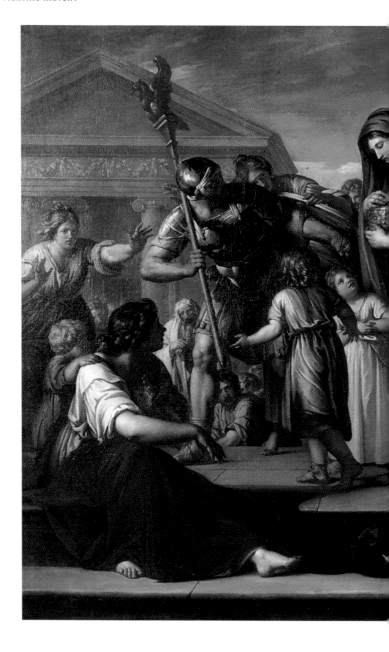

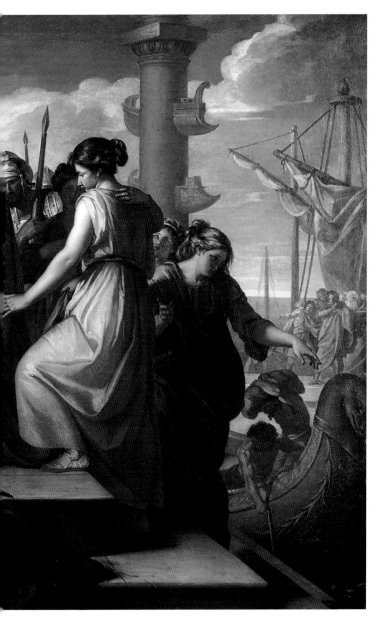

20. GAVIN HAMILTON
Agrippina Landing at Brindisium with the Ashes of Germanicus 1765–72

it might require the mind of a great artist to bring real substance to the dream of a moral universe – a vision rendered still more compelling through the vividness of the painter's images. As Reynolds put it, the artist's invention did not lie in creating the narrative as such – a task for historians and poets – but in his capacity to imagine the Ideal.

Britain's late entry into high art gave eighteenth-century neo-classicism special prominence. For all its influence, however, the age of Reynolds, West, and Copley should not be conceived as setting the terms for the whole history of this genre. Indeed it is simply inconceivable that a tradition of such longevity could flourish without absorbing new influences. The continuing evolution of history painting right down to the present has not yet drawn as much attention as it deserves, but part of the fascination of the subject rests in its invitation to trace the progress of this art form over its extensive career.

As we traverse the half-century that separated the formality of Colin Morison's *Andromache* (FIG.22), Gavin Hamilton's *Agrippina* 1765–72 (FIG.20) or Benjamin West's *Cleombrotus* 1768 (FIG.21) from the animated variety of David Wilkie's *Chelsea Pensioners* 1822 (FIG.23) we are struck by a cluster of changes that helped to soften the austerity of history painting without sacrificing its claim to an elevated public mission. In his *Pensioners*, Wilkie rejected battlefield gallantry in favour of a quasi-domestic setting in which a gathering of old soldiers greet the news of Wellington's victory. By displacing *history's* focus from action to emotion, Wilkie transformed a newspaper into a natural symbol of popular feeling. The painting, not surprisingly, made a strong impression when it was displayed in the Royal Academy. Nonetheless, some critics found it hard to accept this lively scene of anonymous rejoicing as properly a history painting. To them Wilkie's talent remained that of a genre painter who lacked the elevation indispensable to genuine *histories*.

Wilkie's hybridity helped to set a new tone in this period, but he was not of course alone. Beginning in the late 1780s, John

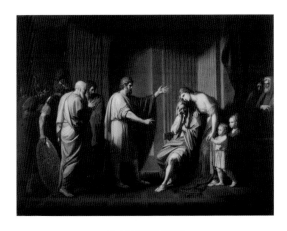

21. BENJAMIN WEST
Cleombrotus Ordered into Banishment by Leonidas II, King of Sparta 1768

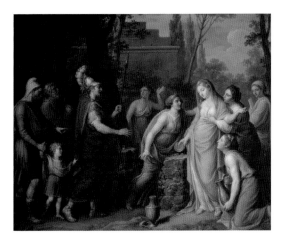

22. COLIN MORISON
Andromache Offering Sacrifice to Hector's Shade c.1760

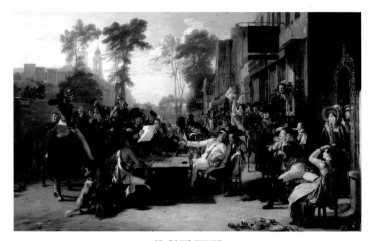

23. DAVID WILKIE
The Chelsea Pensioners Reading the Waterloo Despatch 1822

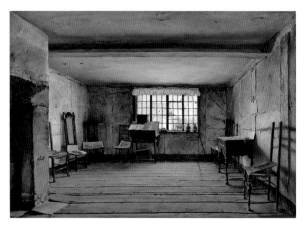

24. HENRY WALLIS
The Room in which Shakespeare Was Born 1853

Boydell's Shakespeare Gallery and Robert Bowyer's History Gallery, both established in London, brought a new spirit to history painting that mixed commercial and nationalistic impulses with a flood of sentimental images, many of them female. So too, William Mulready, with *Convalescent of Waterloo* 1822 (Victoria and Albert Museum, London) went even further than Wilkie himself towards treating a great battle as a site of family emotion and popular memory. The intensification of affective presence was calculated to promote a more social representation of the nation, thus aligning history painting (somewhat belatedly) with parallel changes that had been occurring in historical writing from David Hume to Thomas Babington Macaulay.

This re-distancing gave nineteenth-century history painting a new complexion, easing some difficulties but aggravating others. Secular nationalism produced a more comfortable relation to the state, encouraging new sources of patronage whilst neutralising the religious anxieties that had worried earlier artists such as Hogarth. On the other hand, the more history painting attached itself to the strict factuality of the historical record, the more it risked losing the elevation that had crowned its high purposes. In retrospect, it seems evident that what had made Benjamin West's *Death of General Wolfe* 1770 (National Gallery of Canada, Ottawa) a landmark was not its much-discussed contemporaneity, but rather its remarkable balance between nationalistic self-assertion and Christian transcendence. Once unhinged from religious tradition, however, history painting might appear to sacrifice its cherished elevation to more secular and nationalist purposes, reducing its insistent summoning to an expression of sentimental excess.

The irony is significant. Historicism brought new prominence to an awareness of history, only to reposition so much of the subject to something earthly and ordinary. The problematic result is especially evident in the Pre-Raphaelites, who made it their mission to re-enchant the world even as they subjected it to minute and unsparing description. Henry Wallis's *Room in which Shakespeare Was Born* 1853 (FIG.24) marks every detail of the

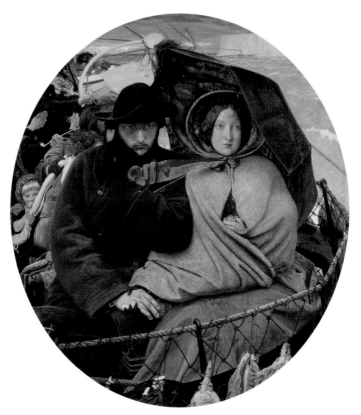

25. FORD MADOX BROWN
The Last of England 1852–5

poet's meagre birthplace – a triumph of Victorian realism – yet the powerful summons of the empty apartment would have been lost if the artist had chosen to populate the scene with a bustling nurse or a contented mother. The same impulses animate Ford Madox Brown's *Last of England* 1852–5, which depicts two unhappy emigrants setting off for hard times in Australia, accompanied by bags of cabbages and a variety of low-life companions (FIG.25). 'This picture', Brown asserts, is 'in the strictest sense historical' ('Exhibition of Work and Other Paintings', in Kenneth Bendiner, *The Art of Ford Madox Brown*, Philadelphia 1998, p.136).

Against such backgrounds we cannot expect more recent times to mimic ancient ways, but neither does it seem foolish to stay alert for lines of descent. In formal terms especially there have been extraordinary innovations. Today's version of a *history*, for example, is as likely to be a photograph or a video as an image on canvas. Modern affects tend to favour irony over the heroic, whilst artists now summon us to causes that might not have been intelligible to previous generations. Much, in short, has changed – but not everything. Richard Hamilton's *The citizen* 1981–3 bears witness to the dignity of the 'human face divine', however wretched the circumstances (FIG.17). And if, as also happens, no human figure comes forward to address us, the absence can be still more troubling. Something essential seems to have been lost or withdrawn, leaving an erasure that the mind cannot bring itself to forget.

CONTEM-PORARY HISTORY PAINTING

Dexter Dalwood interviewed by Greg Sullivan

GS: Part of the impetus for organising the exhibition *Fighting History* at Tate Britain was the fact that history painting appears to be gaining fresh relevance in contemporary art. We wanted to include your work because you have described it as 'contemporary history painting' and you explicitly engage with the history of history painting, and the structures and ideas that relate to it. Why do we keep coming back to this genre?

DD: I didn't set out to make history painting. I'd been painting for a long time before I realised that was the nature of what I was involved in. I started off making fictional spaces based on people, but then on events. I really only started to think of them as history painting when I began to quote from other painters. As an art student in the early 1980s, I found that history painting wasn't on most artists' minds, there was no interest in what it seemed to describe – a history of power and aristocracy, and the reinterpretations of historical events through the classical world. Dark, thickly varnished paintings of people doing things in costumes seemed sort of moth-eaten.

I realised that removing all the figures from my work meant scale became a thing in itself: I could include different motifs and quote different periods of time, as well as different paintings from paintings' own past. So for me, history painting became linked to a history of painting.

Benjamin West had an investment in the idea of the history painter as a kind of historian; that there is some historical truth in what he represents. Your paintings, though, construct scenes via reference to something else, so destabilise any sense of historicism: your *Old Bailey* isn't really based on a representation of the Old Bailey and the pier in your *Brighton Bomb* isn't Brighton Pier. Is this a deliberate undermining of literalness in history painting?

Yes, definitely. If you look at Copley's *Death of Major Peirson* (FIG.4), he wants to get the belts and the insignia right on the costumes, in pursuit of the 'actual', which was important before photography. Our understanding of what things looked like then was mediated by painting, but today if you think about the

classical world, Troy, for example, you can have a fully fledged 360-degree CGI version of it. We can see the sack of Troy by a vast multitude in the cinema. There is no point in striving for verisimilitude now, so artists have long been free to recreate and reconstruct in any way they like.

The subject of Jeremy Deller's *Battle of Orgreave* is both the miners' strike and our relationship to the miners' strike (fig.3). It was filmed in 2000, some of the miners are in the actual film. But the film doesn't need to be an exact record of the event. The people involved in the reconstruction of it are reflecting both on their experience of the day as well as the emotional impact of re-living it again.

Jeremy Deller wrote that *The Battle of Orgreave* is in part a conscious attempt to make people consider the re-enactment as part of the lineage of decisive British battles. There is a recurrent theme in history painting about the artist using the artistic medium to have a role in deciding how people's histories are recorded.

I think the really interesting thing about *The Battle of Orgreave* is what the function of that film will be in fifty years' time. Will it become the quintessential record of the event, displacing the very small amount of real footage there is? Or will something else happen? Will the emotion of *The Battle of Orgreave* and other late twentieth-century works dealing with memory or personal histories in relationship to historical or political events somehow evaporate? Will it become harder to look at those works if you don't have any connection to them? I think that's a difficult thing to think about. If you stand people in front of Goya's *Third of May*, for example, and ask 'well, what is the historical moment of this painting?' people might not exactly remember Spanish history in that level of detail, but the visceral thing which is going on in that painting – the innocents being executed by firing squad – goes right through time and history.

One revisionist aspect of the exhibition, suggested by recent scholarship, is that history painting in Britain seems almost

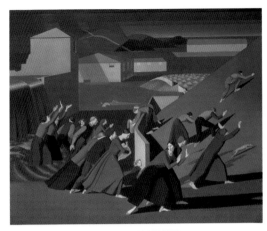

26. WINIFRED KNIGHTS
The Deluge 1920

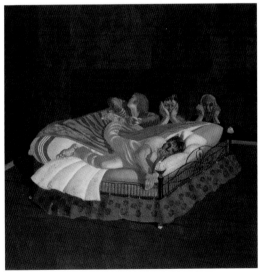

27. STANLEY SPENCER
The Centurian's Servant 1914

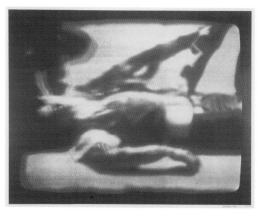

28. RICHARD HAMILTON
Kent State 1970

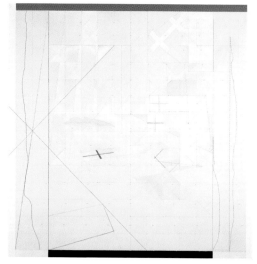

29. RITA DONAGH
Reflection on three weeks in May 1970 1970–1

never to go away. Although we are used to thinking of history painting as the dark thing that modernism rejects at the end of the nineteenth century, we see the survival of history painting in almost every generation, from Winifred Knights (FIG.26) and Stanley Spencer (FIG.27) through to Richard Hamilton. Do you feel that we need to rewrite that whole story of the disappearance of history painting, or do we just need to tell a slightly different story?

Even in my own lifetime the canon of modernism and twentieth-century art is mutating. Artists whose work was not previously seen to be part of the story are now taking their place within the history of this period. In this show you're only talking about British art, and so the relationship to a wider art history is different. One cannot think of British history painting in relation to milestones such as 'once Manet arrived', or 'once modernism arrived'; just because something happened in France, it doesn't mean that artists in Britain were thinking the same way.

The relationship with America seems to also be a recurring motif for British artists, from Copley's *Chatham* to Richard Hamilton and Rita Donagh's responses to the shooting of students at Kent State University in 1970 (FIGS.6, 28, 29). This is also interesting, if we are trying to think about whether we can actually identify a specifically *British* tradition of history painting.

Well, in the twentieth century history was a completely global thing, and we were alerted to what was happening everywhere in a particularly edited way. I remember Richard Hamilton talking about how he was watching TV and saw the image of a wounded student come on the screen, and he took a photograph of the television. He was nearly in tears talking about what had actually happened. Then in the end it becomes quite an abstracted thing – you wouldn't necessarily know by looking at the work what it was: but the title leads you into thinking and negotiating it.

Steve McQueen's *Lynching Tree* (FIG.30), another American subject by a British artist, shows an actual tree that exists to this day and really was used for hangings. I think the work seen in the context of this exhibition creates a space for thinking about the

relationship between what was happening contemporaneously in Southern America and Britain in the early nineteenth century. *Lynching Tree* becomes a historical document that makes connections with British imperialism and so much more; what it talks about underpins the history of the other images in the exhibition.

One of the subjects we haven't spoken about is a subject which is historical and isn't historical, which is *The Deluge* (FIGS.26, 31, 32, 33, 34). In the show there are examples from the early nineteenth-century (when the biblical Deluge was widely thought to be an historical event) right through to your own version of the subject. I guess *The Deluge* has significance for us now because we are currently thinking that there may well be another real flood coming. But the subject also has a less literal significance as it represents shifting time, and both the beginning and the end of history.

I think throughout history, artists have found the biblical idea that there could be this great cleansing at any time an irresistible subject. 'Let's get rid of it – it's the end of everything.' In my painting I was thinking about how pop art eventually swamped gestural abstraction (FIG.34). It attacked what it deemed to be the pomposity of abstract expressionism in one fell swoop, undermining an ideology. Movements don't dominate in the same way now but I liked the idea. When I painted my deluge there had just been Hurricane Katrina, which was the most biblical event of recent times, and the reaction to it was very complicated.

We've included some works in the exhibition which are not paintings – a film, a digital print – but it is mostly paint. And it's true that when critics talked of 'the highest genre' it was usually linked to the specific medium of paint. Do you think that there is something particular to painting that makes it possible to have the most elevated effect? Or that painting and history are somehow intertwined?

30. STEVE MCQUEEN
Lynching Tree 2013

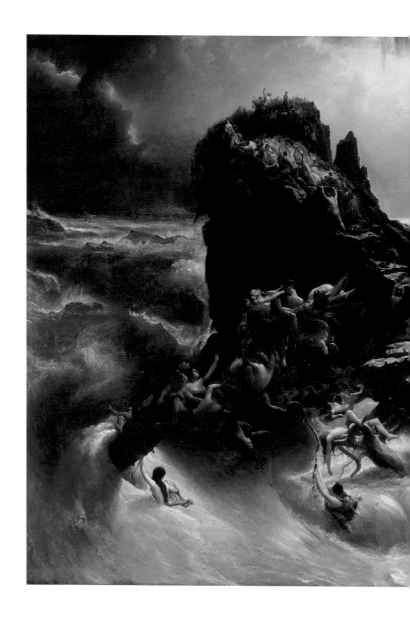

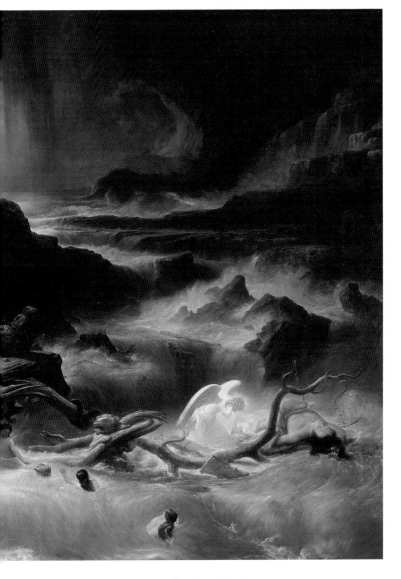

31. FRANCIS DANBY
The Deluge exh.1840

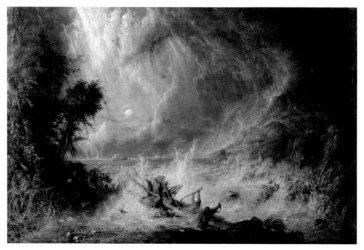

32. WILLIAM WESTALL
The Commencement of the Deluge exh.1848

I can only talk personally in that I think painting's problem is history, in many ways. There are the perennial questions: 'why is it still going?' and 'what's the point in it?' as well as the ubiquitous 'death of painting' argument. I think that to make paintings and to be still interested in making paintings now, one has to acknowledge the history of painting within the work. The sheer quantity of painting in existence provides a vast bank of images that can be recycled by artists. Artists can play with a painting's relationship to the time in which it is made, with their relation to history, with the influences of social context on the way paintings were made and with the contemporary ideologies of the time. It may be bit of a personal obsession, but I'm very interested in that relationship.

It's such an ambitious genre, isn't it? When you decide that you're going to do some vast epic panorama or some scene of historical significance, the opportunities to fail dreadfully and fall prey to the kind of hubris that comes with it at the same time –

Yeah. 'Hubris' is the word I'm looking for!

But there's also the possibility of a kind of 'history from below', that everybody has the right to talk in relation to where they sit in relation to history, and as an artist you will set about it in a certain way, but not with an all-seeing eye...

There is short story by the Russian author Leonid Andreyev [1871–1919] about a man who watches the Crucifixion with a toothache. Even at such a momentous historical moment, this individual has such a very bad toothache that he is only concerned with his own day, if you like. I remember going down to Trafalgar Square to the poll tax riots. There was a real commotion going on but there were still people going to the theatre, coming out of the National Gallery, with no real sense that this was a changing point within British political history. I think that can happen in any situation. So being a witness of history, or depicting history, or reassembling a depiction of history, is all so strangely personal, in terms of one's interaction with it, that it's kind of impossible to do any sort of genuine account of anything. I think that's always

been the case, and that's what is interesting about the history of history painting as a genre from 1760 to now. The reconstructive, revisionist nature of history painting, and the fascinating first interjections of artists in history, is revealed in the show as a completely convoluted, complex mixture of ambitions and hubris.

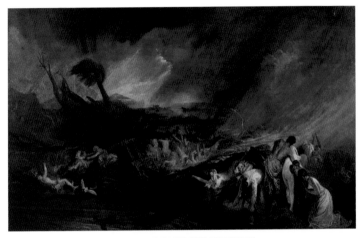

33. JOSEPH MALLORD WILLIAM TURNER
The Deluge ?exh.1805

34. DEXTER DALWOOD
The Deluge 2006

SELECTED FURTHER READING

British history painting features in a good deal of academic art history, although rarely as the principal subject. Recent works that address the genre are: Mark Salber Phillips, *On Historical Distance* (New Haven and London 2013); Martin Myrone, *Bodybuilding: Reforming Masculinities in British Art 1750–1810* (New Haven and London 2006); and Matthew Craske's forthcoming book on Joseph Wright of Derby. John Sunderland's 'Mortimer, Pine and Some Political Aspects of English History Painting', *Burlington Magazine*, vol.116, June 1974, pp.322–5, was an important intervention into the study of British history painting, which had previously focused on a debate around Benjamin West's *The Death of General Wolfe*, beginning with Edgar Wind, 'The Revolution in History Painting', *Journal of the Warburg Institute*, vol.2, 1938, pp.116–27, and Charles Mitchell, 'Benjamin West's *Death of General Wolfe* and the Popular History Piece', in *England and the Mediterranean Tradition* (Oxford 1945), pp.179–92.

Emma Chambers, 'Redefining History Painting in the Academy: The Summer Composition Competition at the Slade School of Fine Art, 1898–1922', *Journal of Visual Culture*, vol.6, no.1, 2005, pp.79–100, and the other articles in this useful edition, address the notion of the 'decline' of the history painting in the nineteenth and early twentieth centuries, and were helpful for forming the thesis of the exhibition. For the re-thinking of history painting in the modern and contemporary period, see David Green and Peter Seddon (eds.), *History Painting Reassessed* (Manchester 2000), and Thomas Crow's essay in the exhibition catalogue *Dexter Dalwood: Recent History* (Gagosian Gallery, (London 2006).

LIST OF ILLUSTRATIONS

Works are listed alphabetically by artist.
Unless otherwise stated, works are in the Tate collection and photography
is copyright © Tate Photography 2015

Fig.25
Ford Madox Brown 1821–1893
The Last of England 1852–5
Oil on panel 82.5 × 75 (oval)
Birmingham Museums and Art Gallery
Photo: Birmingham Museums and Art
Gallery / Bridgeman Images

Fig.2
John Everett Millais 1829–1896
Speak! Speak! 1895
Oil paint on canvas
167.6 × 210.8
Presented by the Trustees of the Chantrey
Bequest 1895

Fig.9
John Everett Millais 1829–1896
The Boyhood of Raleigh 1870
Oil paint on canvas
120.6 × 142.2
Presented by Amy, Lady Tate in memory of
Sir Henry Tate 1900

Fig.7
John Minton 1917–1957
The Death of Nelson 1952
183 × 244.2
Royal College of Art, London
© Royal College of Art
Photo: Royal College of Art, London, UK /
Bridgeman Images

Fig.22
Colin Morison 1732–1810
*Andromache Offering Sacrifice to
Hector's Shade* c.1760
Oil paint on canvas
61.5 × 76
Purchased 1991

Fig.1
Robert Edge Pine 1730–1788
*John De Warenne, 6th Earl of Surrey,
Giving His Answer to the
King's Justices on the Enforcement of the
Statute of Quo
Warranto 1278* 1771
Oil paint on canvas
The National Trust, Sudbury Hall, The
Vernon Collection. Acquired through the
National Land Fund and transferred to the
National Trust in 1967
Photo: © National Trust Images

Fig.11
Edward Poynter 1836–1919
A Visit to Aesculapius 1880
Oil paint on canvas
151.1 × 228.6
Presented by the Trustees of the Chantrey
Bequest 1880

Fig.16
Joshua Reynolds 1723–1792
Colonel Tarleton 1782
Oil paint on canvas
236 × 145.5
The National Gallery, London. Bequeathed
by Mrs Henrietta Charlotte Tarleton, 1951
Photo: © The National Gallery, London

Fig.27
Stanley Spencer 1891–1959
The Centurian's Servant 1914
Oil paint on canvas
114.3 × 114.3
Presented by the Trustees of the Chantrey
Bequest 1960
© Estate of Stanley Spencer

Fig.33
Joseph Mallord William Turner 1775–1851
The Deluge ?exh.1805
Oil paint on canvas
142.9 × 235.6
Accepted by the nation as part of the
Turner Bequest 1856

Fig.24
Henry Wallis 1830–1916
*The Room in which Shakespeare Was
Born* 1853
Oil paint on board
29.2 × 41.9
Purchased 1955

Fig.21
Benjamin West 1738–1820
*Cleombrotus Ordered into Banishment
by Leonidas II, King of
Sparta* 1768
Oil paint on canvas
138.4 × 185.4
Presented by W. Wilkins 1827

Fig.32
William Westall 1781–1850
The Commencement of the Deluge
exh.1848
Oil paint on canvas
127 × 193
Purchased 1956

Fig.23
David Wilkie 1785–1841
*The Chelsea Pensioners Reading the
Waterloo Despatch* 1822
Oil paint on wood
97 × 158
Apsley House, London
Photo: © English Heritage

Fig.5
William Frederick Yeames 1835–1918
Amy Robsart exh.1877
Oil paint on canvas
281.5 × 188.5
Presented by the Trustees of the Chantrey
Bequest 1877

Fig.10
Johan Zoffany 1733–1810
*The Death of Captain James Cook,
14 February 1779* c.1795
Oil paint on canvas
137.2 × 182.9
© National Maritime Museum, Greenwich,
London, Greenwich Hospital Collection

ACKNOWLEDGEMENTS

This book has been published on the occasion of the exhibition *Fighting History* at Tate Britain. Tate is grateful to the lenders who generously contributed their works to the show. Our thanks to Octavius and Joanne Black, the ISelf Collection, the National Gallery, the National Maritime Museum, the National Trust, the Royal College of Art, the Saatchi Gallery, and Robert Diamant of the Carl Freedman Gallery. My special thanks to Penelope Curtis, Director of Tate Britain, for supporting the show, Judith Severne for overseeing the publication, and to Clare Barlow, my co-curator. Conversations with Mark Salber Phillips and Dexter Dalwood have helped to shape my thinking on the continuities in the history painting tradition, and I would like to extend my warm thanks to both. Colleagues at Tate have been very generous with their advice and comments on the show, especially Martin Myrone, Alison Smith and Emma Chambers. Thanks also to Lorna Booth, David Brown, Juliet Carey, Caroline Corbeau-Parsons, Matthew Craske, Lucy Cutler, Diana Douglas, Valeria Fioretti, Juleigh Gordon-Orr, Carol Jacobi, Carolyn Kerr, Andy Shiel, Clarrie Wallis, Tina Weidner, Andrew Wilson, and all other colleagues involved in realising the show. Additional research for the exhibition was carried out by Juliette Wallace.

Mark Salber Phillips wishes to express his gratitude to Dr Cynthia Roman, whose generous invitation to share a class on history painting at Yale's Walpole Library has done so much to shape his understanding of the subject.

This exhibition has been made possible by the provision of insurance through the Government Indemnity Scheme. Tate Britain would like to thank HM Government for providing Government Indemnity and the Department for Culture, Media and Sport and Arts Council England for arranging the indemnity.

Greg Sullivan

AUTHORS

Greg Sullivan is Curator British Art, 1750–1830, Tate.

Mark Salber Phillips is Professor of History and member of the Institute for Comparative Studies in Literature, Arts, and Culture, Carleton University, Ottawa. He is the author of *On Historical Distance* (2013).

Dexter Dalwood is an artist. He lives and works in London.